ESSENTIAL PLEASURES COLORING BOOK FOR ADULTS

CRYSTAL
COLORING BOOKS

Copyright © 2018 Crystal Coloring Books
All rights reserved.

ISBN: 9781790384686

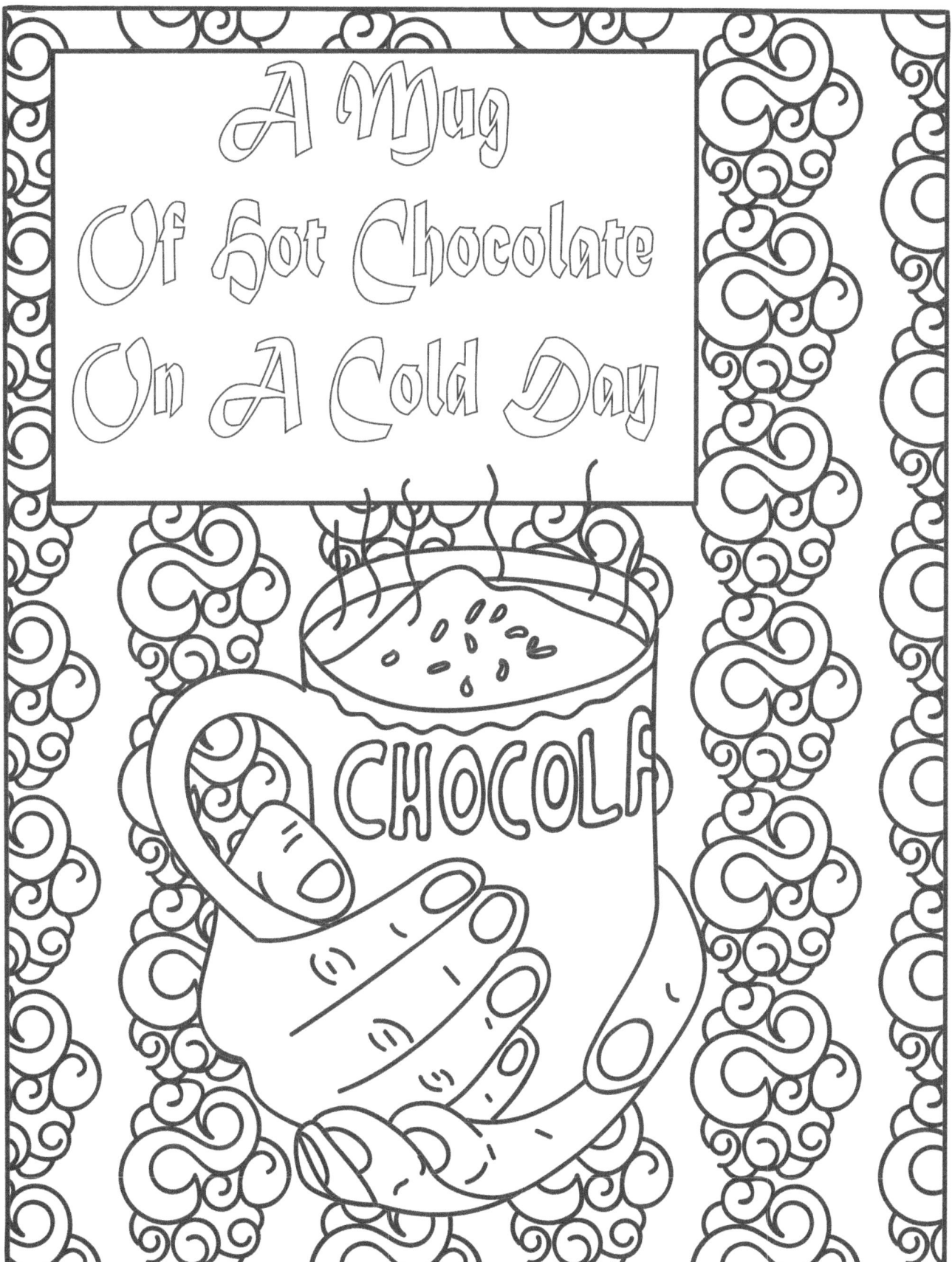

COLOR TEST PAGE

COLOR TEST PAGE

www.ingramcontent.com/pod-product-compliance
Lightning Source LLC
Chambersburg PA
CBHW081615220526
45468CB00010B/2890